Ohio
Total Eclipse Guide

Official Commemorative 2024 Keepsake Guidebook

2024 Total Eclipse State Guide Series

Aaron Linsdau

Sastrugi Press

Copyright © 2019 by Aaron Linsdau

All rights reserved. No part of this book may be reproduced or transmitted in any form or by any means, electronic or mechanical, including photocopying, recording, or by any computer system without the written permission of the author, except where permitted by law.

Sastrugi Press / Published by arrangement with the author

Ohio Total Eclipse Guide: Official Commemorative 2024 Keepsake Guidebook

 The author has made every effort to accurately describe the locations contained in this work. Travel to some locations in this book is hazardous. The publisher has no control over and does not assume any responsibility for author or third-party websites or their content describing these locations, how to travel there, nor how to do it safely. Refer to local regulations and laws.
 Any person exploring these locations is personally responsible for checking local conditions prior to departure. You are responsible for your own actions and decisions. The information contained in this work is based solely on the author's research at the time of publication and may not be accurate in the future. Neither the publisher nor the author assumes any liability for anyone climbing, exploring, visiting, or traveling to the locations described in this work. Climbing is dangerous by its nature. Any person engaging in mountain climbing is responsible for learning the proper techniques. The reader assumes all risks and accepts full responsibility for injuries, including death.

Sastrugi Press
PO Box 1297, Jackson, WY 83001, United States
www.sastrugipress.com
Quantity sales: Special discounts are available on quantity purchases by corporations, associations, and others. For details, contact the publisher at the address above.

Library of Congress Catalog-in-Publication Data
Library of Congress Control Number: 2018914099
Linsdau, Aaron
Ohio Total Eclipse Guide / Aaron Linsdau-1st United States edition
p. cm.
1. Nature 2. Astronomy 3. Travel 4. Photography
Summary: Learn everything you need to know about viewing, experiencing, and photographing the total eclipse in Ohio on April 8, 2024.

ISBN-13: 978-1-944986-30-8 (paperback)
ISBN-13: 978-1-64922-024-0 (large print)

508.4—dc23

Printed in the United States of America when purchased in the United States

All photography, maps and artwork by the author, except as noted.

10 9 8 7 6 5 4 3 2

Contents

Introduction	4
All About Ohio	**6**
Overview of Ohio	6
Weather	11
Forest Fires	13
Road Closures Due to Fires	14
Wilderness and Forest Park Safety	15
Eclipse Day Safety	17
All About Eclipses	**19**
Total vs Partial Eclipse	20
Early Myth & Astronomy	22
Contemporary American Solar Phenomena	24
Future American Eclipses	26
Viewing and Photographing the Eclipse	**27**
Planning Ahead	28
Understanding Sun Position	29
Eclipse Data for Selected Locations	31
Eclipse Photography	**31**
Eclipse Photography Gear	34
Camera Phones	36
Viewing Locations Around Ohio	**43**
Remember the Ohio Total Eclipse	**65**

Introduction

Thank you for purchasing this book. It has everything you need to know about the total eclipse in Ohio on April 8, 2024.

A total eclipse passing through the United States is a rare event. The last US total eclipse was in 2017. It traveled from Oregon to South Carolina. The last American total eclipse prior to that was in 1979!

The next total eclipse over the US will not be until April 8, 2024. It will pass over Texas, the Midwest, and on to Maine. After that, the next coast-to-coast total eclipse will be in 2045.

It's imperative to make travel plans early. You will be amazed at the number of people swarming to the total eclipse path. Some might say watching a partial versus a total eclipse is a similar experience. It's not.

This book is written for Ohio visitors and anyone else viewing the eclipse. You will find general planning, viewing, and photography information inside. Should you travel to the eclipse path in Ohio in April, be prepared for an epic trip. The estimates based on the 2017 eclipse suggest that millions will converge on Ohio.

Some hotels in the communities and cities along the path of totality in Ohio have already been contacted by people to make reservations. Finding lodging along the eclipse path may be a major challenge.

Resources will be stretched far beyond the normal limits. Think gas lines from the late 1970s. It may be likely that traffic along highways will come to a complete standstill during this event. Be prepared with backup supplies.

Many smaller Ohio towns are far from any major city. Ohio country roads can be slow. Please obey posted speed limits for the safety of everyone. Be cautious about believing a map application's estimate of travel time in Ohio.

People in communities along the path of the total eclipse may rent out properties for this event. With this major celestial spectacle in the spring of 2024, be assured that Ohio "hasn't seen anything yet."

Is this to say to avoid Ohio or other areas during the eclipse? Not at all! This guidebook provides ideas for interesting, alternative, and memorable locations to see the eclipse. It will be too late to rush to

a better spot once the eclipse begins. Law enforcement will be out to help drivers reconsider speeding.

Please be patient and careful. There will be a large rush of people from all over the world, converging on Ohio to enjoy the total eclipse. Be mindful of other drivers on eclipse weekend, as they may not be familiar with Ohio roads.

You should feel compelled to play hooky on April 8. Ask for the day off. Take your kids out of school. They'll be adults before the next chance to see a total eclipse over America. Create family memories that will last a lifetime. Sastrugi Press does not normally advocate skipping school or work. Make an exception because this is too big an event to miss.

Wherever you plan to be along the total eclipse path, leave early and remember your eclipse glasses. People from all around the planet will converge on Ohio. Be good to your fellow humans and be safe. We all want to enjoy this spectacular show.

Visit www.sastrugipress.com/eclipse for the latest updates for this state eclipse book series.

Author Information

Polar explorer and motivational speaker Aaron Linsdau's first book, *Antarctic Tears*, is an emotional journey into the heart of Antarctica. He ate two sticks of butter every day to survive. Aaron coughed up blood early in the expedition and struggled with equipment failures. Despite the endless difficulties, he set a world record for surviving the longest solo expedition to the South Pole.

Aaron teaches how to build resilience to overcome adversity by managing attitude. He shares his techniques for overcoming adrenaline burnout and constant overload. He inspires audiences to face their challenges with a new perspective. As a motivational speaker, Aaron talks about courage, resilience, attitude, safety, and risk. He hopes that you will be inspired and have an enjoyable time watching the total eclipse in Ohio.

Visit his websites at www.aaronlinsdau.com or www.ncexped.com.

All About Ohio

Overview of Ohio

The state of Ohio has a strong tourism industry and is a significant player in the history of the United States. Visitors spend over $35 billion annually in the state. Ohio's visionaries have created some of the best tourist attractions in the country. Perhaps one of the most well-known attractions is the Cincinnati Zoo and Botanical Gardens. The Gardens themselves will be in full bloom in April during the total eclipse. Some of the featured flowers are the tulips and daffodils. The photographic possibilities are endless. The zoo itself was founded in 1875, making it the second-oldest zoo in America.

Ohio was important to the history of the country long before it became a state. Evidence of Paleo-Indians has been found from over 11,000 years BC. It was the frontier before America was founded, the forefront of the fur trade between the French and American traders with the indigenous people. After the Civil War, Ohio became one of the central hubs for industrial jobs.

Ohio's statehood is a source of historical contention. President Jefferson signed the act of Congress on February 19, 1803, to approve Ohio's constitution and boundaries. However, Congress deemed the official date as the same as the state of Louisiana, and neither became official states until 1812. President Eisenhower ended the argument on August 7, 1953. He signed a law to set the date as March 1, 1803.

A historical site that tourists should visit in April is the National Veterans Memorial and Museum in Columbus. Visitors can pay re-

spects to the country's veterans before or after the eclipse. Note that Columbus is outside the total eclipse path, so sights should be seen on a separate day. Cincinnati is also outside the total eclipse path. Either city is an excellent starting point to drive north for the eclipse.

The state is the home of some of the most notable public figureheads in the history of the country. Neil Armstrong, Thomas Edison, President James Garfield, and Annie Oakley are but a few of the notable Americans who called Ohio home.

Harriet Beecher Stowe, who wrote the influential *Uncle Tom's Cabin*, resided in Cincinnati. This home, dubbed the Harriet Beecher Stowe House, is open to visitors. Stop here to catch a glimpse of a residence used for the underground railroad.

Dayton may be the most aerial location to watch the eclipse from. It is home to the National Museum of the United States Airforce and the Wright Brothers National Memorial. Both are well connected to flight and space travel, making them a fun place to experience the total eclipse. You can even ride roller coasters during the total eclipse at Cedar Point near Sandusky.

Another historical site is the Clyde Historical Museum. Sherwood Anderson is noted as one of the founders of realism. The art museum is located in Winesburg, Ohio. It will be open in early April for the convenience of tourists seeking indoor activities before or after the eclipse.

Perhaps one of the most unique experiences a tourist can partake of is to visit one of the many cat cafés in Columbus, Dayton, Cleveland, and Mason. The experience is designed for the comfort of the cats, where visitors have one hour to visit the café and interact with the animals. Coffee and pastries are served in one section of the café, but the ability to still see the cats are available. One of the best features of this tourist attraction is that customers can adopt one of the animals if they wish.

It's not just the cats in the café's lounging in the many places Ohio offers to visitors. Outdoor areas such as Wayne National Forest, Cuyahoga Valley National Forest, and Zaleski State Forest are all among the most scenic places in the state. Tourists can find peace and relaxation in the vast views and scenery. One of the perks of

these state parks is they offer hammock areas where tourists can relax and enjoy the views. Wherever you choose to watch the total eclipse from, there are countless attractions to keep yourself entertained in Ohio.

Hotels and Motels During the Eclipse

Once excitement of the total eclipse over Ohio spreads, rooms will become scarce. Many hotels in towns along the path of totality in western states sold out for a year or more during the 2017 total eclipse. Ohio is not alone in this challenge. Hotels all along the path of totality will sell out in anticipation of the 2024 total eclipse.

What does this mean for eclipse visitors? Lodging and room rentals in eclipse towns will be at a massive premium. Does that mean all hope is lost to find a place to stay? Not at all. But you will have to be creative. There will be few, if any, hotel rooms available in these eclipse cities by early 2024. Accommodations in the cities and towns along the path of the eclipse will be difficult to come by.

In summer 2017, the author searched on Hotels.com for rooms along the 2017 total eclipse path on the weekend of August 21 and found many major cities sold out. Once word of the 2024 eclipse spreads, room rates will increase and availability will drop.

Search for rooms farther away from the eclipse path. If you are willing to stay in cities outside the eclipse path, you will have better success at finding rooms. As the eclipse approaches, people will book rooms farther from the totality path. By early spring, rooms in cities near the total eclipse path may be unavailable. The effect of this event will be felt across Ohio and the rest of the United States.

Think regionally when looking for rooms. Be prepared to search far and wide during this major event. If a five-hour drive is manageable, your lodging options greatly expand, but it also increases your travel risk.

Internet Rentals

To find rooms to stay in towns along the eclipse path, try a web service such as Airbnb.com. Note that some people rent out rooms or homes illegally, against zoning regulations. Cities will feel the crunch of inquiries early due to others who experienced the 2017 eclipse.

If cities fully enforce zoning laws, authorities may prevent your weekend home rental. Online home rentals during the eclipse will be a target for rental scams. People from out of the area steal photos and descriptions, then post the home for rent. You send your check or wire money to a "rental agent" then show up to find you have been scammed. If the deal sounds strange or too good to be true, run away.

Camping

If you can book a campsite, do it as soon as you can. Do not wait. All areas in the national forests are first-come, first-served. Forest roads may be packed. Expect all areas to be swarming with people. Show up early to stake out your spot. Consider staying farther away and driving early on April 8.

Please respect private land too. Ohio folks don't take kindly to people overrunning their property without permission. In a big state with millions of residents, people are very protective, but they're friendly, too. You never know what you might be able to arrange with a smile and a bit of money.

This all said, there are plenty of camping opportunities throughout Ohio. You don't have to sleep exactly on the eclipse path. If you're ready to rough it, there are national forest camping options.

Government agencies will meet years in advance to talk about how to manage the influx of people. Every possible government agency will be working full time to enforce the various rules and regulations.

National Parks and Monuments

Finding a camping site at any state park, national park, or national monument along the eclipse path in Ohio will be challenging. To watch the eclipse from any location, you do not have to sleep in it. You just need to drive there in the morning.

Law enforcement will be present on the eclipse weekend. Hundreds of thousands of people are expected in the region. Parking may overflow. It will make parking lots and lines on Black Friday at the mall look uncrowded. For an event of this magnitude, find your location as early as possible.

The first sentence of the national parks mission statement is:

"The National Park Service preserves unimpaired the natural and cultural resources and values of the national park system for the enjoyment, education, and inspiration of this and future generations."

Roadside camping (sleeping in your car) is not allowed in national monuments or parks. Park facilities are only designed to handle so many people per day. Water, trash collection, and toilets can only withstand so much. If you notice trash on the ground, take a moment to throw it away. Protect your national park and help out. Rangers are diligent and hardworking but they can only do so much to manage the expected crowds.

National and State Forests

There are national and state forest options in Ohio. They all have camping opportunities. The forest service manages undeveloped and primitive campsites. Be sure to check for any fire restrictions. Check with individual agencies for last-minute information and regulations. The forest service requires proper food storage. Plan to purchase food and water before choosing your campsite. Below is a partial list of national forests along or near the total eclipse path:

Wayne National Forest:
https://www.fs.usda.gov/wayne
Zaleski State Forest:
http://forestry.ohiodnr.gov/zaleski

Backcountry service roads abound in Ohio. Maps for forests are available at local visitor centers and bookstores. This book's website has digital copies of some forest maps.

Printed national forest maps are large and detailed. They have illustrated road paths, connections, and other vital travel information not available on digital device maps. Viewing digital maps on your smartphone or mobile pad is difficult. If you plan to camp in the forest, a real paper map is a wise investment.

Camping in federal wilderness areas is also allowed. Those areas

afford the ultimate backcountry experience. However, be aware that no vehicle travel is allowed in the specially designated areas. This ban includes: vehicles, bikes, hang gliders, and drones. You can travel only on foot or with pack animals.

Sleep in Your Car

Countless RVs, campers, trucks, cars, and motorcycles will flood Ohio. Sleeping in your car with friends is tolerable. Doing so with unadventurous spouses or children is another matter.

Do not be caught along the path of the total eclipse without some sort of plan, especially in the bigger cities of Ohio. The whole path of totality will fill with people on April 8.

Useful Local Webcams

Local webcams are handy to make last-minute travel decisions. The webcams are sensitive enough to show headlights at night. Use them to determine if there are issues before traveling out. Eclipse traffic will add to the morning commuter traffic.

The smartphone application Wunderground is useful to check on webcams in one place. Selected the webcams are listed in the app. Whether you use this app or another, an Internet search will reveal many useful webcams for your search.

Weather

It's all about the weather during the eclipse. Nothing else will matter if the sky is cloudy. You can be nearly anywhere along the path in Ohio and catch a view of the event when traffic comes to a standstill. But if there's a cloud cover forecast, seriously reconsider your viewing location.

Travel early wherever you plan to go. Attempting to change locations an hour before the eclipse due to weather will likely cause you to miss the event. Ohio country roads can be narrow and slow. The number of vehicles will cause unexpected backups.

Modern Forecasts

Use a smartphone application to check the up-to-date weather. Wunderground is a good application and has relatively reliable forecasts for the region. The hourly forecast for the same day has been rather accurate for the last two years. The below discussion refers to features found in the Wunderground app. However, any application with detailed weather views will improve your eclipse forecasting skills.

Cloud Cover Forecast

The most useful forecast view is the visible and infrared cloud-coverage map. Avoid downloading this app the night before and trying to learn how to read it. Practice reading them at home. It's imperative to understand how to interpret the maps early.

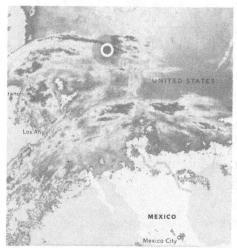

Infrared cloud map showing the worst case eclipse cloud cover.
Courtesy of National Weather Service.

All cloud cover, night or day, will appear on an infrared map. Warm, low-altitude clouds are shown in white and gray. High-altitude cold clouds are displayed in shades of green, yellow, red, and purple. Anything other than a clear map spells eclipse-viewing problems.

To improve your weather guess, use the animated viewer of the cloud cover. It will give you a sense of cloud motion. You can discern whether clouds or rain are moving toward, away from, or circulating around your location.

Normal Ohio Weather Pattern

Due to the direction of the jet stream, most weather travels across the Pacific Ocean, through the western states, over the Rockies, and then into Ohio. On occasion, weather can approach from Canada or Mexico. Due to the nature of the storms from the Arctic, weather in

Ohio can be unpredictable.

The common weather pattern in April is slightly warm in the afternoon and mildly cool in the evenings. Passing cold fronts in spring can bring unexpected cloud cover and rains.

Historically, Ohio tends to have moderate cloud cover during April. Prepare to make adjustments. If anything other than clear skies are predicted, drive to other parts of Ohio, Indiana, Pennsylvania.

Be aware of tornadoes in Ohio. Although the peak tornado season is June, there have been many recorded tornadoes in April. Pay attention to the weather forecast. If dangerous weather is predicted, your main concern should be safety rather than chasing an eclipse.

Consider that slow-moving clouds can obscure the sun for far longer than the four-minute duration of the totality. The time of totality is so short that you do not want to risk it. Missing it due to a single cloud will be a major disappointment.

Local Eclipse Weather Forecasts

Local town and city newspapers, radio, and television stations around Ohio will have a weekend edition with articles discussing the eclipse weather. However, conditions change unpredictably in Ohio. A three-day forecast for April may be incorrect.

Finding the Right Location to View Eclipse Effects

One of the peculiarities of total eclipses is that the entire show is not only in the sky. There are other unusual effects seen during the total eclipse that are worth looking for.

The first effect to watch for is the crescent moon shapes created from leaf shadows on the ground. They're best viewed on a sidewalk or asphalt. They can only be observed during the partial eclipse. The other effect that is worth watching for is the shadow bands or "snakes" as they're commonly called.

Shadow banding is seen right before and after the totality takes place. They're best observed on smooth, plain-colored surfaces. If you plan to be in the forest for the eclipse, you may struggle to see the bands but will likely see crescent shadows all around on the ground.

One of the supreme challenges with all of these effects is choosing what to watch. You can see the crescent shadows in the hour before and after the totality but shadow banding happens before or after totality. It is more difficult to look away from the eclipse than you think.

Road Closures and Traffic

Highways connecting various Ohio towns in the total eclipse path will be heavily impacted on the weekend before and day of the eclipse. As was found in the 2017 total eclipse, there is no way to predict which areas will be impacted.

Planning ahead is essential to give you the best opportunity to enjoy the eclipse without the nightmare of being stuck in traffic for hours on end. The traffic in Oregon and Idaho was stunning, so imagine what it will be like for Ohio.

Update yourself with the latest road report information from the Ohio road condition website:

https://www.ohgo.com/

It's imperative to plan early and have one if not more backup plans in case of difficult travel conditions. April weather is unpredictable and variable.

If you believe it's necessary to leave a town to watch the eclipse, do so the night before or extremely early in the morning. RVs are common, and trains of them crawl through popular areas.

Ohio Information

Cellular Phones

Cellular "cell" phone service in some remote Ohio locations may be problematic. Most of the time there is good coverage along the main highways and interstates. However, even along major thoroughfares,

there can be little or no coverage.

It's possible to find zones where text messages will send when phone calls are impossible. If you cannot make a phone call, the chance of having data coverage for web surfing or e-mail is low.

Please look up any information or communicate what you need before departing from the main roads around Ohio. Bureau of Land Management (BLM) areas sometimes have coverage. Planned to be self-contained. Plan for your cell phone not to connect.

You may find yourself out of cell service. With a large number of cell users in a concentrated area, coverage and data speed may collapse as well. Search on the phrase "cell phone coverage breathing".

Wilderness and Forest Safety

All Ohio forest and wilderness areas are full of wild animals. Although beautiful, wild animals can be dangerous. They can easily injure or kill people, as they are far more powerful than humans. Do not try to feed any wild animals, including squirrels, foxes, and chipmunks, as they can carry diseases. These suggestions apply to all public lands.

Ticks

Ticks exist all across the United States, but not all species transmit disease. Ticks cannot fly or jump, but they climb grasses in shrubs in order to attach to people or animals that pass by. Ticks feed on the blood of their host. In doing so, they can transmit potentially life-threatening diseases such as Lyme disease.

Spiders

Although the chance of encountering a venomous spider is low, it is not uncommon to encounter them. The two dangerous spiders in the state are the black widow and brown recluse. Should you encouter either species, simply leave it alone. If you are bitten, seek immediate medical attention, as their toxin can be life-threatening.

Venomous Snakes

There are multiple species of venomous snakes in Ohio including

the Copperhead, Cottonmouth, Eastern Massasauga Rattlesnake, and Timber Rattlesnake. Although these reptiles are not generally aggressive, they can strike when provoked or threatened. Of the approximately 8,000 people annually bitten by venomous snakes in the United States, ten to fifteen people die according to the U.S. Food and Drug Administration.

The best way to avoid rattlesnake encounters is to be mindful of your environment. Do not place your hands or feet in locations where you cannot clearly see the surroundings. Avoid heavy brush or tall weeds where snakes hide during the day. Step on a log or rock rather than over it, as a hidden snake might be on the other side. Rattlesnakes may not make any noise before striking.

Avoid handling all snakes. Should you be bitten, stay calm and call 911 or emergency dispatch as soon as possible. Transport the victim to the nearest medical facility immediately. Rapid professional treatment is the best way to manage rattlesnake bites. Refer to US Forest Service and professional medical texts for more information on managing rattlesnakes injuries.

Bears

The forests of Ohio are potentially home to black bears. Though they are listed rarely seen, they have been sighted in the state. Although they often appear docile, they can become aggressive if threatened. In the unlikely event of an attack, fight back against the bear. Use whatever you have at your disposal to defend yourself. Report all negative or aggressive bears to the local authorities.

If a bear hears you, it will usually vacate the area. Bear charges are often caused by unexpected and surprise encounters. Noise is the best defense to avoid surprising bears. Regularly clap, make noise, and talk loudly. The Ohio Department of Natural Resources website has more specific information on safety and food management in bear country at http://wildlife.ohiodnr.gov/species-and-habitats/nuisance-wildlife/black-bears-in-ohio.

It is recommended to stay one hundred yards (300 feet) away from all bears. They are exciting to see but need their space. Refer to current forest or park regulations for more safety information.

Mountain Lions

Though listed as extinct in the state, there have been recent reports of mountain lions in Ohio by the Ohio Department of Natural Resources. If you encounter a mountain lion, do not run. Keep calm, back away slowly, and maintain eye contact. Do all you can to appear larger. Stand upright, raise your arms, or hoist your jacket. Never bend over or crouch down. If attacked, fight back.

Eclipse Day Safety

1. Hydrate

Spring temperatures are usually mild to warm. The excitement of the event can distract you from managing hydration. Drink plenty of water. Consume more than you would at home.

2. Eye Safety time

Use certified eclipse safety glasses at all times when viewing the partial eclipse. Only remove the glasses when the totality happens. Give your eyes time to rest. They can dry out and become irritated. Bring FDA approved eye drops to keep your eyes moist.

3. Sun exposure

Facing at the sun for three hours can result in sunburns. Wear sunglasses and liberally apply sunscreen to avoid sunburns.

4. Eat well

Keep your energy up. Appetite loss is common when traveling. Maintain your normal eating schedule.

5. Prepare for temperature changes

Temperatures will drop rapidly during the eclipse and also once the sun sets. Bring appropriate clothing.

6. Talk with your doctor

If the humidity or heat bothers you talk with your doctor before traveling. Seek professional medical attention for serious symptoms.

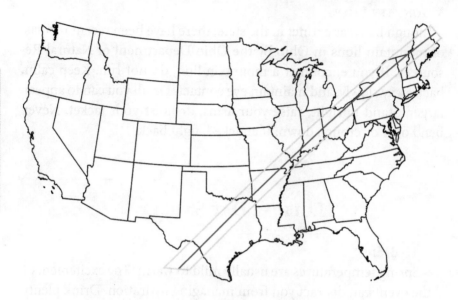

Total eclipse path across the United States (approximate).

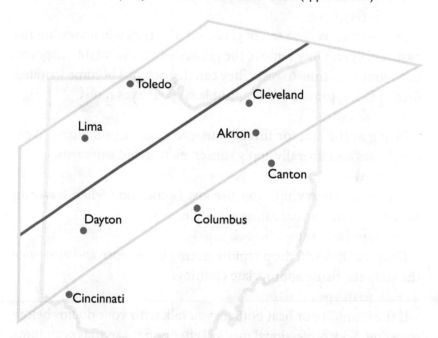

Total eclipse path across Ohio (approximate).

All About Eclipses

How an Eclipse Happens

An eclipse occurs when one celestial body falls in line with another, thus obscuring the sun from view. This occurs much more often than you'd think, considering how many bodies there are in the solar system. For instance, there are over 150 moons in the solar system. On Earth, we have two primary celestial bodies: the sun and the moon. The entire solar system is constantly in motion, with planets orbiting the sun and moons orbiting the planets. These celestial bodies often come into alignment. When these alignments cause the sun to be blocked, it is called an eclipse.

For an eclipse to occur, the sun, Earth, and moon must be in alignment. There are two types of eclipses: solar and lunar. A solar eclipse occurs when the moon obscures the sun. A lunar eclipse occurs when the moon passes through Earth's shadow. Solar eclipses are much more common, as we experience an average of 240 solar eclipses a century compared to an average of 150 lunar eclipses. Despite this, we are more likely to see a lunar eclipse than a solar eclipse. This is due to the visibility of each.

For a solar eclipse to be visible, you have to be in the moon's shadow. The problem with viewing a total eclipse is that the moon casts a small shadow over the world at any given time. You have to be in

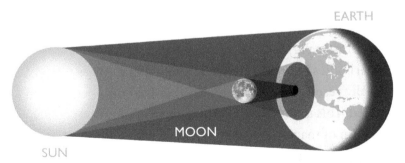

* ILLUSTRATION NOT TO SCALE

a precise location to view a total eclipse. The issue that arises is that most of these locations are inaccessible to most people. Though many would like to see a total solar eclipse, most aren't about to set sail for the middle of the Pacific Ocean. In fact, a solar eclipse is visible in the same place on the world on average every 375 years. This means that if you miss a solar eclipse above your hometown, you're not going to see another one unless you travel or move.

It's much easier to catch a glimpse of a lunar eclipse, even though they occur at a much lower frequency than their solar counterparts. A lunar eclipse darkens the moon for a few hours. This is different than a new moon when it faces away from the sun. During these eclipses, the moon fades and becomes nearly invisible.

Another result of a lunar eclipse is a blood moon. Earth's atmosphere bends a small amount of sunlight onto the moon turning it orange-red. The blood moon is caused by the dawn or dusk light being refracted onto the moon during an eclipse.

Lunar eclipses are much easier to see. Even when the moon is in the shadow of Earth, it's still visible throughout the world because of how much smaller it is than Earth.

Total vs. Partial Eclipse

What is the difference between a partial and total eclipse? A total eclipse of either the sun or the moon will occur only when the sun, Earth, and the moon are aligned in a perfectly straight line. This ensures that either the sun or the moon is partially or completely obscured.

In contrast, a partial eclipse occurs when the alignment of the three celestial bodies is not in a perfectly straight line. These types of eclipses usually result in only a part of either the sun or the moon being obscured. This is often what led to ancient civilizations believing that some form of magical beast or deity was eating the sun or the moon. It appears as though something has taken a bite out of either the sun or the moon during a partial eclipse.

Total eclipses, rarer than partial eclipses, still occur quite often. It's more difficult for people to be in a position to experience such an event firsthand. Total solar eclipses can only be viewed from a small portion of the world that falls into the darkest part of the moon's shadow. Often this happens in the middle of the ocean.

The Moon's Shadow

The moon's shadow is divided into two parts: the umbra and the penumbra. The former is much smaller than the latter, as the umbra is the innermost and darkest part of the shadow. The umbra is thus the central point of the moon's shadow, meaning that it is extremely small in comparison to the entire shadow. For a total solar eclipse to be visible, you need to be directly beneath the umbra of the moon's shadow. This is because that is the only point at which the moon completely blocks the view of the sun.

In contrast, the penumbra is the region of the moon's shadow in which only a portion of the light cast by the sun is obscured. When

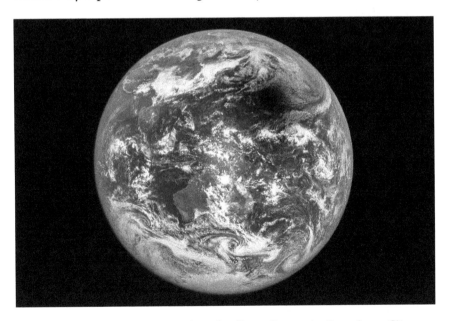

Total eclipse shadow 2016 as seen from 1 million miles on the Deep Space Climate Observatory satellite. Courtesy of NASA.

standing in the penumbra, you are viewing the eclipse at an angle. In the penumbra, the moon does not completely block the sun from view. This means that while the event is a total solar eclipse, you'll only see a partial eclipse. The umbra for the April 8 eclipse is over one hundred miles wide. The penumbra will cover much of the United States.

To provide some context, one total solar eclipse we experienced occurred on March 9, 2016, and was visible as a partial eclipse across most of the Pacific Ocean, parts of Asia, and Australia. However, the only place in the world to view this total solar eclipse was in a few parts of Indonesia.

Due to the varied locations and the brief periods for which they're visible, it's difficult to see each and every eclipse that occurs. Many people don't even realize that they have occurred. Consider that the umbra of the moon represents such a small fraction of the entire shadow and the majority of our planet is comprised of water. Thus, the rarity of being able to view a total solar eclipse increases significantly because it's likely that the umbra will fall over some part of the ocean rather than a populated landmass.

Eclipses Throughout History

Ancient peoples believed eclipses were from the wrath of angry gods, portents of doom and misfortune, or wars between celestial beings. Eclipses have played many roles in cultures, creating myths since the dawn of time. Both solar and lunar eclipses affected societies worldwide. Inspiring fear, curiosity, and the creation of legends, eclipses have cast a long shadow in the collective unconscious of humanity throughout history.

Early Myth & Astronomy

Documented observations of solar eclipses have been found as far back in history as ancient Egyptian and Chinese records. Timekeeping was important to ancient Chinese cultures. Astronomical

observations were an integral factor in the Chinese calendar. The first observation of a solar eclipse is found in Chinese records from over 4,000 years ago. Evidence suggests that ancient Egyptian observations may predate those archaic writings.

Many ancient societies, including Roman, Greek and Chinese civilizations, were able to infer and foresee solar eclipses from astronomical data. The sudden and unpredictable nature of solar eclipses had a stressful and intimidating effect on many societies that lacked the scientific insight to accurately predict astronomical events. Relying on the sun for their agricultural livelihood, those societies interpreted solar eclipses as world-threatening disasters.

In ancient Vietnam, solar eclipses were explained as a giant frog eating the sun. The peasantry of ancient Greece believed that an eclipse was the sign of a furious godhead, presenting an omen of wrathful retribution in the form of natural disasters. Other cultures were less speculative in their investigations. The Chinese Song Dynasty scientist Shen Kuo proved the spherical nature of the Earth and heavenly bodies through scientific insight gained by the study of eclipses.

THE ECLIPSE IN NATIVE AMERICAN MYTHOLOGY

Eclipses have played a significant role in the history of the United States. Before Europeans settled in the Americas, solar eclipses were important astronomical events to Native American cultures. In most native cultures, an eclipse was a particularly bad omen. Both the sun and the moon were regarded as sacred. Viewing an eclipse, or even being outside for the duration of the event, was considered highly taboo by the Navajo culture. During an eclipse, men and women would simply avert their eyes from the sky, acting as though it was not happening.

The Choctaw people had a unique story to explain solar eclipses. Considering the event as the mischievous actions of a black squirrel and its attempt to eat the sun, the Choctaw people would do their best to scare away the cosmic squirrel by making as much noise as

possible until the end of the event, at which point cognitive bias would cause them to believe they'd once again averted disaster on an interplanetary scale.

CONTEMPORARY AMERICAN SOLAR PHENOMENA

The investigation of solar phenomena in twentieth-century American history had a similarly profound effect on the people of the United States. A total solar eclipse occurring on the sixteenth of June, 1806, engulfed the entire country. It started near modern-day Arizona. It passed across the Midwest, over Ohio, Pennsylvania, New York, Massachusetts, and Connecticut. The 1806 total eclipse was notable for being one of the first publicly advertised solar events. The public was informed beforehand of the astronomical curiosity through a pamphlet written by Andrew Newell entitled *Darkness at Noon, or the Great Solar Eclipse*.

This pamphlet described local circumstances and went into great detail explaining the true nature of the phenomenon, dispelling myth and superstition, and even giving questionable advice on the best methods of viewing the sun during the event. Replete with a short historical record of eclipses through the ages, the *Darkness at Noon* pamphlet is one of the first examples of an attempt to capitalize on the mysterious nature of solar eclipses.

Another notable American solar eclipse occurred on June 8, 1918. Passing over the United States from Washington to Florida, the eclipse was accurately predicted by the U.S. Naval Observatory and heavily documented in the newspapers of the day. Howard Russell Butler, painter and founder of the American Fine Arts Society, painted the eclipse from the U.S. Naval Observatory, immortalizing the event in *The Oregon Eclipse*.

Four more total solar eclipses occurred over the United States in the years 1923, 1925, 1932, and 1954, with another occurring in 1959. The October 2, 1959, solar eclipse began over Boston, Massachusetts. It was a sunrise event that was unviewable from the ground level. Em-

inent astronomer Jay Pasachoff attributed this event to sparking his interest in the study of astronomy. Studying under Professor Donald Menzel of Williams College, Pasachoff was able to view the event from an airline hired by his professor.

To this day, many myths surround the eclipse. In India, some local customs require fasting. In eastern Africa, eclipses are seen as a danger to pregnant women and young children. Despite the mystery and legend associated with unique and rare astronomical events, eclipses continue to be awe-inspiring. Even in the modern day, eclipses draw out reverential respect for the inexorable passing of celestial bodies. They are a reminder of the intimate relationship between the denizens of Earth and the universe at large.

Present Day Eclipses

The year 2017 brought the world's most-watched total eclipse in history on August 21, when a total solar eclipse crossed the United States. An annular eclipse, a "ring of fire," will pass over the United States in 2023 from Oregon to Texas. Though impressive, it will not

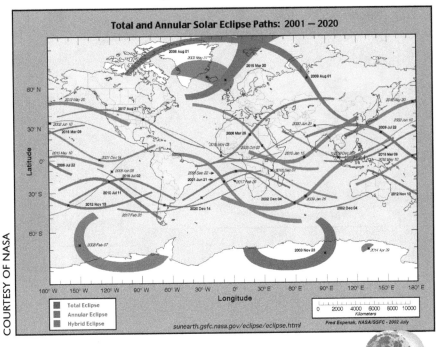

compare to the 2024 total eclipse. There is little in nature that equals the spectacle of the sun's corona and seeing stars in the day.

There will be multiple partial, annular, or hybrid eclipses across the world before the 2024 total eclipse. However many are in remote, inaccessible, or potentially dangerous locations on the globe. In 2019 and 2020, Chile and Argentina will experience total eclipses. The next total eclipse after that will occur over Antarctica in 2021. An extremely rare hybrid eclipse will happen in 2023 over the Indian Ocean, Australia, and Indonesia.

The next total solar eclipse viewable from the United States will occur on April 8, 2024. It will be visible in fifteen states: Texas, Oklahoma, Arkansas, Missouri, Tennessee, Kentucky, Illinois, Indiana, Ohio, Pennsylvania, Michigan, New York, Vermont, New Hampshire, and Maine.

Viewing and Photographing the Eclipse

AT-HOME PINHOLE METHOD

Use the pinhole method to view the eclipse safely. It costs little but is the safest technique there is. Take a stiff piece of single-layer cardboard and punch a clean pinhole. Let the sun shine through the pinhole onto another piece of cardboard. That's it!

Never look at the sun through the pinhole. Your back should be toward the sun to protect your eyes. To brighten the image, simply move the back piece of cardboard closer to the pinhole. To see it larger, move the back cardboard farther away. Do not make the pinhole larger. It will only distort the crescent sun.

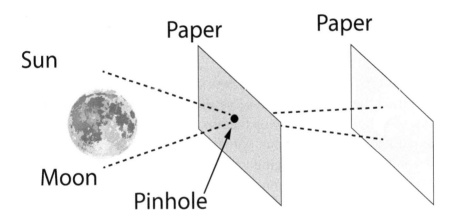

WELDING GOGGLES

Welding goggles that have a rating of fourteen or higher are another useful eclipse viewing tool. The goggles can be used to view the solar eclipse directly. Do not use the goggles to look through binoculars or telescopes, as the goggles could potentially shatter due to intense direct heat. Avoid long periods of gazing with the goggles. Look away every so often. Give your eyes a break.

SOLAR FILTERS FOR TELESCOPES

The ONLY safe way to view solar eclipses using telescopes or binoculars is to use solar filters. The filters are coated with metal

to diminish the full intensity of the sun. Although the filters can be expensive, it is better to purchase a quality filter rather than an inexpensive one that could shatter or melt from the heat.

The filters attach to the front of the telescope for easy viewing. Remember to give your telescope cooling breaks. Rapid heating can damage your equipment with or without filters attached.

Watch Out for Unsafe Filters

There are several myths surrounding solar filters for eclipse viewing. In order for filters to be safe, they must be specially designed for looking at a solar eclipse. The following are all unsafe for eclipse viewing and can lead to retinal damage: developed colored or chromogenic film, black-and-white negatives such as X-rays, CDs with aluminum, smoked glass, floppy disk covers, black-and-white film with no silver, sunglasses, or polarizing films.

Watch Out for Unsafe Eclipse Glasses

During the 2017 total eclipse, several vendors sold eclipse glasses that were not safe for viewing the sun. Although they were marketed as safe and were even marked with the ISO 12312-2 certification, they did not block eye-damaging visible, infrared, and ultraviolet light. Check the American Astronomical Society's website (eclipse.aas.org) for a list of reputable eclipse glasses vendors.

Viewing with Binoculars

When viewing the eclipse with binoculars, it is important to use solar filters on both lenses until totality. Only then is it safe to remove the filter. As the sun becomes visible after totality, replace the filters for safe viewing. Protect your pupils. Remember to give your binoculars a cool-down break between viewings. They can overheat rapidly from being pointed directly at the sun even with filters attached.

Planning Ahead

There are many things to keep in mind when viewing a total eclipse. It is important to plan ahead to get the most out of this extraordinary experience.

Understanding Sun Position

All compass bearings in this book are true north. All compasses point to Earth's magnetic north. The difference between these two measurements is called magnetic declination. The magnetic declination for Ohio is:

7° 13' W ± 0° 22' (for Columbus in 2024)

Adjust the declination from the azimuth bearing as given in the text, and set your compass to that direction.

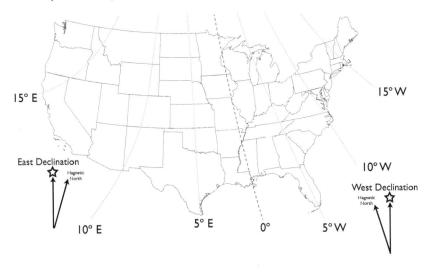

If you purchase a compass with a built-in declination adjustment, you can change the setting once and eliminate the calculations. The Suunto M-3G compass has this correction. A compass with a sighting mirror or wire will help you make a more accurate azimuth sighting.

The Suunto M-3G also has an inclinometer. This allows you to measure the elevation of any object above the horizon. Use this to figure out how high the sun will be above your position.

You can also use a smartphone inclinometer and compass for this purpose. Make sure to calibrate your smartphone's compass before every use, otherwise it might indicate the wrong bearing. Set the smartphone compass for true north to match the book. Understand the compass prior to April 8. There will be little time to guess or

search on Google. Smartphone and GPS compasses are "sticky." Their compasses don't swing as freely as a magnetic compass does.

The author has used his magnetic compass for azimuth measurements and a smartphone to measure elevation. Combining these two tools will allow you to make the best sightings possible.

Outdoor sporting goods stores in most towns and cities carry compasses. Purchase and practice with a good compass in your hometown well before the event. Take the time to learn how to use it before the day of the eclipse. You do not want to struggle with orienteering basics under pressure.

Sun Azimuth

Azimuth is the compass angle along the horizon, with 0° corresponding to north, and increasing in a clockwise direction. 90° is east, 180° is south, and 270° is west.

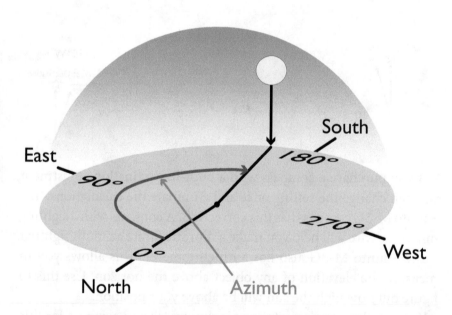

Sun Elevation

Altitude is the sun's angle up from the horizon. A 0° altitude means exactly on the horizon and 90° means "straight up."

Using the sun azimuth and elevation data, you can predict the position of the sun at any given time. Positions given in this book coincide with the time of eclipse totality unless otherwise noted.

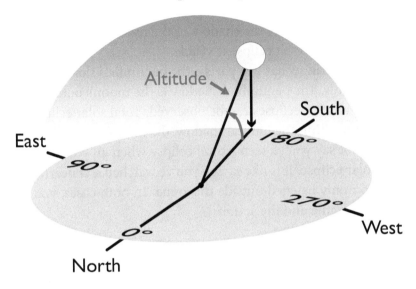

ECLIPSE DATA FOR SELECT OHIO LOCATIONS

LOCATION	TOTALITY START (EDT)
AKRON	3:14:06PM
CLEVELAND	3:13:39PM
DAYTON	3:09:21PM
LIMA	3:09:43PM
MANSFIELD	3:12:15PM
TOLEDO	3:12:13PM

ECLIPSE PHOTOGRAPHY

Photographing an eclipse is an exciting challenge, as the moon's shadow moves near 1,600MPH. There is an element of danger and the pressure of time. Looking at the unfiltered sun through a camera can permanently damage your vision and your camera. If you are unsure, just enjoy the eclipse with specially designed eclipse glasses. Keep a solar filter on your lens during the eclipse and remove for the duration of totality!

Partial Vs. Total Solar Eclipse

To successfully and safely photograph a partial and total eclipse, it is important to understand the difference between the two. A solar eclipse occurs when the moon is positioned between the sun and Earth. The region where the shadow of the moon falls upon Earth's surface is where a solar eclipse is visible.

The moon's shadow has two parts—the penumbral shadow and the umbral shadow. The penumbral shadow is the moon's outer shadow where partial solar eclipses can be observed. Total solar eclipses can only be seen within the umbral shadow, the moon's inner shadow.

You cannot say you've seen a total eclipse when all you saw was a partial solar eclipse. It is like saying you've watched a concert, but in reality, you only listened outside the arena. In both cases, you have missed the drama and the action.

Photographing A Partial And Total Solar Eclipse

Aside from the region where the outer shadow of the moon is cast, a partial solar eclipse is also visible before a total solar eclipse within

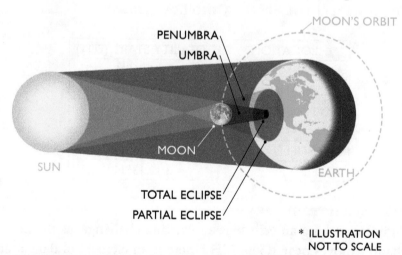

* ILLUSTRATION NOT TO SCALE

the inner shadow region. In both cases, it is imperative to use a solar filter on the lens for both photography and safety reasons. This is the only difference between taking a partial eclipse and a total eclipse photograph of the sun.

To photograph a total solar eclipse, you must be within the Path of Totality, the surface of the Earth within the moon's umbral shadow.

THE CHALLENGE

A total solar eclipse only lasts for a couple of minutes. It is brief, but the scenario it brings is unforgettable. Seeing the radiant sun slowly being covered by darkness gives the spectator a high level of anticipation and indescribable excitement. Once the moon completely covers the sun's radiance, the corona is finally visible. In the darkness, the sun's corona shines, capturing the crowd's full attention. Watching this phenomenon is a breathtaking experience.

Amidst all the noise, cheering, and excitement, you have no more than a few minutes to take a perfect photograph. The key to this is planning. You need to plan, practice, and perfect what you will do when the big moment arrives because there is no replay. The pressure is enormous. You only have a short time to capture the totality and the sun's corona using different exposures.

PLAN, PRACTICE, PERFECT

It is important to practice photographing before the actual phenomenon arrives. Test your chosen imaging setup for flaws. Rehearse over and over until your body remembers what you will do from the moment you arrive at your chosen spot to the moment you pack up and leave the area.

You will discover potential problems regarding vibrations and focus that you can address immediately. This minimizes the variables that might affect your photographs at the most critical moment.

It's common for experienced eclipse chasers to lose track of what they plan to do. Write down what you expect to do. Practice it time and again. Play annoying, distracting music while you practice. Try photographing in the worst weather possible. Do anything you can to practice under pressure. Eclipse day is not the time to practice.

Once the sun is completely covered, don't just take photographs. Capture the experience and the image of the total solar eclipse in your mind as well. Set up cameras around you to record not just the total solar eclipse but also the excitement and reaction of the crowd.

Eclipse Photography Gear

What do you need to photograph the total eclipse? There are only a few pieces of equipment that you'll need. Preparing to photograph an eclipse successfully takes time. Not only do you have to be skilled and have the right gear, you have to be in the correct place.

Basic Eclipse Photography Equipment
- Solar viewing glasses (verify authenticity)
- Lens solar filter
- Minimum 300mm lens
- Stable tripod that can be tilted to 60° vertical
- High-resolution DSLR
- Spare batteries for everything
- Secondary camera to photograph people, the horizon, etc.
- Remote cable or wireless release

Additional Items
- Video camera
- Video camera tripod
- Quality pair of binoculars
- Solar filters for each binocular lens
- Photo editing software

Equipment to Prepare Before the Big Day

A. **Solar viewing glasses**
You need a pair of solar viewing glasses as the eclipse approaches.

B. **Solar Filter**
Partial and total eclipse photography is different from normal photography. Even if only 1% of the sun's surface is visible, it is still approximately 10,000 times brighter than the moon. Before totality, use a solar filter on your lens. Do not look at the sun with your eyes. It can cause irreparable damage to your retinas.

DO NOT leave your camera pointed at the sun without a solar filter attached. The sun will melt the inside of your camera. Think of a magnifying glass used to torch ants and multiply that by one hundred.

C. Lens

To capture the corona's majesty, you need to use a telescope or a telephoto lens. The best focal length, which will give you a large image of the sun's disk, is 400mm and above. You don't want to waste all your efforts by bringing home a small dot where the black disk and majestic corona are supposed to be.

D. Tripod

Bring a stable enough tripod to support your camera properly to avoid unsteady shots and repeated adjustments. Either will ruin your photos. It also needs to be portable in case you need to change locations for a better shot. *Shut off camera stabilization on a tripod!*

E. Camera

You need to remember to set your camera to its highest resolution to capture all the details. Set your camera to:

- 14-bit RAW is ideal, otherwise
- JPG, Fine compression, Maximum resolution

Bracket your exposures. Shoot at various shutter speeds to capture different brightnesses in the corona. Note that stopping your lens all the way down may not result in the sharpest images.

Choose the lowest possible ISO for the best quality while maintaining a high shutter speed to prevent blurred shots. Set your camera to manual. Do not use AUTO ISO. Your camera will be fooled. The night before, test the focus position of your lens using a bright star or the moon.

Constantly double-check your focus. Be paranoid about this. You can deal with a grainy picture. No amount of Photoshop will fix a blurry, out-of-focus picture.

F. Batteries

Remember to bring fresh batteries! Make sure that you have enough power to capture the most important moments. Swap in fresh batteries thirty minutes before totality.

G. Remote release

Use a wired or wireless remote release to fire the camera's shutter. This will reduce the amount of camera vibration.

H. Video Camera

Run a video camera of yourself. Capture all the things you say and do during the totality. You'll be amazed at your reaction.

I. Photo editing software

You will need quality photo editing software to process your eclipse images. Adobe Lightroom and Photoshop are excellent programs to extract the most out of your images. Become well versed in how to use them at least a month before the eclipse.

J. Smartphone applications

The following smartphone applications will aid in your photography planning: Wunderground, Skyview, Photographer's Ephemeris, Sunrise and Sunset Calculator, SunCalc, and Sun Surveyor among others.

Camera Phones

Smartphone cameras are useful for many things but not eclipse photography. An iPhone 6 camera has a 63° horizontal field of view and is 3264 pixels across. If you attempt to photograph the eclipse, the sun will be a measly 30-40 pixels wide depending on the phone. Digital pinch zoom won't help here. If you want *National Geographic* images, you'll need a serious camera and lens, far beyond any smartphone.

Consider instead using a smartphone to run a time-lapse of the entire event. The sun will be minuscule when shot on a smartphone. Think of something else exciting and interesting do to with it. Purchase a Gorilla Pod, inexpensive tripod, or selfie stick and mount the smartphone somewhere unique.

Also, partial and total eclipse light is strange and ethereal. Consider using that light to take unique pictures of things and people. It's rare and you may have something no one else does.

Focal Length & the Size of Sun

The size of the sun in a photo depends on the lens focal length. A 300mm lens is the recommended minimum on a full-frame (FF) DSLR. Lenses up to this size are relatively inexpensive. For more magnification, use an APS-C (crop) size sensor. Cameras with these sensors provide an advantage by capturing a larger sun.

For the same focal length, an APS-C sensor will provide a greater apparent magnification of any object. As a consequence, a shorter, less expensive lens can be used to capture the same size sun.

The below figure shows the size of the sun on a camera sensor at various focal lengths. As can be seen with the 200mm lens, the sun is quite small. On a full-frame camera at 200mm, the sun will be 371 pixels wide on a Nikon D810, a 36-megapixel body. A lower resolution FF camera will result in an even smaller sun.

Printing a 24-inch image shot on a Nikon D810 with a 200mm lens at a standard 300 pixels per inch results in a small sun. On this size paper, the sun will be a miserly 1.25 inches wide!

Photographing the eclipse with a lens shorter than 300mm will leave you with little to work with. Using a 400mm lens and printing a 24-inch print will result in a 2.5-inch-wide sun. For as massive as the sun is, it is a challenge to take a large photograph of the sun. The sun will appear to move fast with a 500mm lens, too. Plan to adjust.

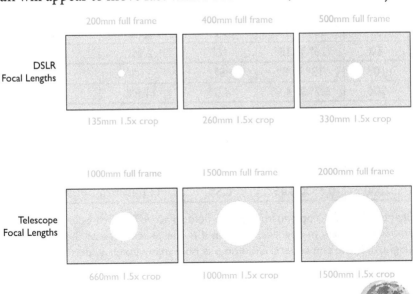

FOCAL LENGTH	FOV FULL FRAME	FF VERT. ANGLE	% OF FF	SUN PIXEL SIZE
14	104° X 81°	81°	0.7%	32.1
20	84° X 62°	62°	0.9%	41.9
28	65° X 46°	46°	1.2%	56.5
35	54° X 38°	38°	1.4%	68.5
50	40° X 27°	27°	2.0%	96.4
105	19° X 13°	13°	4.1%	200.2
200	10° X 7°	7°	7.6%	371.9
400	5° X 3.4°	3.4°	15.6%	765.6
500	4° X 2.7°	2.7°	19.6%	964.2
1000	2° X 1.3°	1.3°	40.8%	2002.5
1500	1.4° X 0.9°	0.9°	58.9%	2892.6
2000	1° X 0.68°	0.68°	77.9%	3828.4

Chart 1: Full-frame camera field of view. The 3rd column is the vertical field of view in degrees. Column 4 is the percentage of the total sensor height that the sun covers. Column 5 is how many pixels wide the sun will be on a 36MP Nikon D810. (Values are estimates)

FOCAL LENGTH	FOV CROP	CROP VERT DEG	% OF CROP	SUN PIXEL SIZE
14	80° X 58°	58°	0.9%	33.9
20	61° X 43°	43°	1.2%	45.8
28	45° X 31°	31°	1.7%	63.5
35	37° X 25°	25°	2.1%	78.7
50	26° X 18°	18°	2.9%	109.3
105	13° X 8°	8°	6.6%	245.9
200	6.7° X 4.5°	4.5°	11.8%	437.2
400	3.4° X 2°	2°	26.5%	983.7
500	2.7° X 1.8	1.8°	29.4%	1093.0
1000	1.3° X 0.9°	0.9°	58.9%	2186.0
1500	0.9° X 0.6°	0.6°	88.3%	3278.9
2000	0.6° X 0.45°	0.5°	117.8%	4371.9

Chart 2: APS-C Crop sensor camera field of view. The 3rd column is the vertical field of view in degrees. Column 4 is the percentage of the total sensor height that the sun covers. Column 5 is how many pixels wide the sun will be on a 12mp Nikon D300s. (Values are estimates)

The big challenge is the cost of the lens. Lenses longer than 300mm are expensive. They also require heavier tripods and specialized tripod heads. The 70-300mm lenses from Nikon, Canon, Tamron, and others are relatively affordable options. It is worth spending time at a local camera shop to try different lenses. Long focal-length lenses are a significant investment, especially for a single event.

To achieve a large eclipse image, you will need a long focal-length lens, ideally at least 400mm. A standard 70-300mm lens set to 300mm will show a small sun. At 500mm, the sun image becomes larger and covers more of the sensor area. The corona will take up a significant portion of the frame. By 1000mm, the corona will exceed the capture area on a full-frame sensor. See the picture in this chapter for sun size simulations for different focal lengths.

Suggested Exposures

To photograph the partial eclipse, the camera must have a solar filter attached. If not, the intense light from the sun may damage (fry) the inside of your camera. This has happened to the author. The exposure depends on the density (darkness) of the solar filter used.

As a starting point, set the camera to ISO 100, f/8, and with the solar filter on, try an exposure of 1/2000. Make adjustments based on the filter used, histogram, and highlight warning.

Turn on the highlight warning in your camera. This feature is commonly called "blinkies." This warning will help you detect if the image is overexposed or not.

Once the Baily's Beads, prominences, and corona become visible, there will only be a few minutes to take bracketed shots. It will take at least eleven shots to capture the various areas of the sun's corona and stars. The brightness varies considerably. No commercially available camera can capture the incredible dynamic range of the different portions of the delicate corona. This requires taking multiple photographs and digitally combining them afterward.

During totality, try these exposure times at ISO 100 and f/8: 1/4000, 1/2000, 1/1000, 1/250, 1/60, 1/30, 1/15, 1/4, 1/2, 1 sec, and 4 sec.

Disable camera/lens stabilization on a tripod!

Photography Time

Set the camera to full-stop adjustments. It will reduce the time spent fiddling. As an example, the author tried the above shot sequence, adjusting the shutter speed as fast as possible.

It took thirty-three seconds to shoot the above 11 shots using 1/3-stop increments. This was without adjusting composition, focus, or anything else but the shutter speed. When the camera was set to full stop increments, it only took twenty-two seconds to step through the same shutter speed sequence. Use a remote release to reduce camera shake.

Assuming the totality lasts less than two minutes, only four shot sequences could be made using 1/3-stop increments. Yet six shot sequences could be made when the camera was set to full stop steps. Zero time was spent looking at the back LCD to analyze highlights and the histogram.

Now add in the bare minimum time to check the highlight warning. It took sixty-three seconds to shoot and check each image using full stops. And that was without changing the composition to allow for sun movement, bumping the tripod, etc. Looking at the LCD ("chimping") consumed **half** of the totality time.

This test was done in the comfort of home under no pressure. In real world conditions, it may be possible to successfully shoot only one sequence. If you plan to capture the entire dynamic range of the totality, you must practice the sequence until you have it down cold. If you normally fumble with your camera, do not underestimate the difficulty, frustration, and stress of total eclipse photography.

Most importantly, trying to shoot this sequence allowed for zero time to simply look at the totality to enjoy the spectacle.

Avoid Last Minute Purchases

You should purchase whatever you think you'll need to photograph the eclipse early. This event will be nothing short of massive. Remember the hot toy of the year? Multiply that frenzy by a thousand. Everyone will want to try to capture their own photo.

Do not wait until the last few weeks before the eclipse to purchase cameras, lenses, filters, tripods, viewing glasses, and associated material. Consider that the totality of the eclipse will streak across

America. Everyone who wants to photograph the eclipse will order at the same time. If you wait until too late to buy what you need, it's conceivable that solar filters to create a total eclipse photo will be sold out in the United States. All filters sold out during the 2017 total eclipse. Whether this happens or not, do not wait to make your purchases. It may be too late.

PRACTICE

You will need to practice with your equipment. Things may go wrong that you don't anticipate. If you've never photographed a partial or total eclipse, taking quality shots is more difficult than you think. Practice shooting the sequence with a midday sun. This will tell you if you have your exposures and timing correct. Figure out what you need well in advance.

Practice photographing the full moon and stars at night. Capture the moon in full daylight to learn how your camera reacts. Astrophotography is challenging and requires practice.

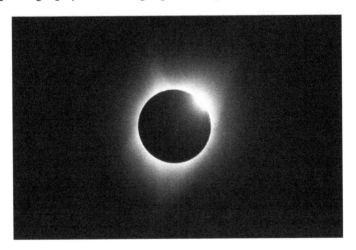

The August 21, 2017, eclipse as seen in Jackson, WY, shot with a Nikon D800 with an 80-400mm lens set to 340mm. The sun is 644 pixels wide on the 7360x4912 image.

This image is shown straight out of the camera without modification. Even with a high-quality camera and lens, photographing an eclipse is challenging.

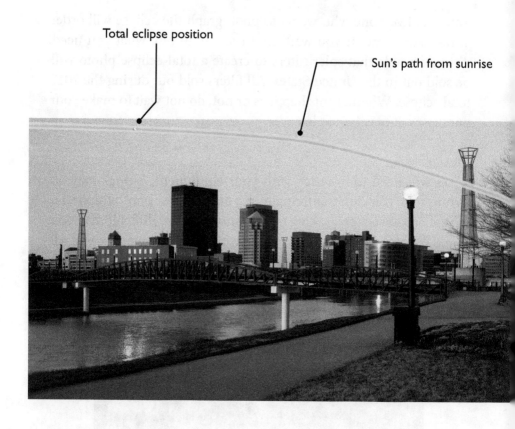

The eclipse will follow this approximate path on the afternoon of April 8, 2024. Image of downtown Dayton, Ohio.

Note that this image is a simulation and approximation the sun's path and where the total eclipse may appear from one perspective. Refer to the eclipse position data for a more accurate location.

☉ is the symbol for the sun and first appeared in Europe during the Renaissance.
☾ is the ancient symbol for the moon.

Viewing Locations Around Ohio

Tens of thousands of people will travel to and around Ohio to view the total eclipse. There are few obstructions and there is a vast amount of space to view the total eclipse from.

If the weather is questionable, seek out a new location as soon as possible. If you wait until the hour before the eclipse, you may find yourself stuck in traffic, as others will be looking for a viewing location. Be safe on the roadways, as drivers may be distracted.

This section contains popular, alternative, and little-known locations to watch the eclipse. As long as there are no clouds or smoke from fires, the partial eclipse will be viewable from anywhere in the state.

SUGGESTED TOTAL ECLIPSE VIEW POINTS

TOWNS AND CITIES

- Akron
- Cleveland
- Dayton
- Findlay
- Fremont
- Greenville
- Hamilton
- Kenton
- Lima
- Lorain
- Mansfield
- Marion
- Sandusky
- Sidney
- Toledo
- Upper Sandusky
- Warren

Columbus

Ohio Total Eclipse Path

UNIQUE LOCATIONS

- Cuyahoga Valley NP
- Indian Lake State Park
- Kelleys Island State Park
- Lake Erie

Akron

Elevation: 1,004 feet
Population: 197,846
Main road/hwy: I-77

Overview

Located thirty miles south of Cleveland, Akron is the fifth largest city in Ohio, and it is the seat of Summit County. Akron is home to a wide array of points of interest and attractions. The Akron Art Museum, which was opened in 1922, has a collection of art that dates back to 1850. The Akron Civic Center is located at the heart of downtown, and it has been responsible for providing the community with a pristine location for live performances and entertainment for decades. Lock 3 is another entertainment amphitheater that hosts festivals and concerts.

Getting There

Drive south from Cleveland on I-77 for thirty-two miles to reach Akron.

Totality Duration

2 minutes 49 seconds

Notes

The city of Akron's website is a good starting place to search for total eclipse information. Visit it at https://www.akronohio.gov/.

Event	Time (EDT)	Altitude	Azimuth
Sunrise	6:57:00AM	0°	79°
Eclipse Start	1:59:03PM	55°	193°
Totality Start	3:14:06PM	49°	222°
Totality End	3:16:56PM	48°	223°
Eclipse End	4:28:59PM	37°	243°
Sunset	7:59:00PM	0°	280°

Cleveland

Elevation:	653 feet
Population:	385,525
Main road/hwy:	Multiple

Overview

Cleveland is the second largest city in Ohio and is located on the southern shore of Lake Erie. The city is home to the Playhouse Square Center, second only in size to New York City's Lincoln Center for Performing Arts. Cleveland's Rock and Roll Hall of Fame is located on the shores of Lake Erie and is well worth a visit if you are a music lover. The city has served as a location for numerous independent films and major movies. Its amalgamation of people from different parts of the world make it a place to be for any lover of tasty, diverse food.

Getting There

Cleveland is a major city in the United States and can be reached by air, train, bus, or car.

Totality Duration

3 minutes 49 seconds

Notes

Visit the news website https://www.cleveland.com/ for updates on events, lodging, and travel in Cleveland.

Event	Time (EDT)	Altitude	Azimuth
Sunrise	6:57:00AM	0°	79°
Eclipse Start	1:59:15PM	55°	193°
Totality Start	3:13:39PM	48°	221°
Totality End	3:17:28PM	48°	223°
Eclipse End	4:28:53PM	37°	242°
Sunset	8:00:00PM	0°	281°

DAYTON

Elevation: 738 feet
Population: 140,371
Main road/hwy: Multiple

OVERVIEW

Dayton is the sixth largest city in Ohio and the fourth largest metropolitan area in the state. It is highly noted for being affiliated with the aviation industry. The city is the birthplace of Orville Wright, and it also houses the National Museum owned by the US Air Force. The city is also home to some of the greatest patents, inventors and innovators, most notably the Wright brothers and their invention of powered flight. The city features multiple parks such as Carillon Historical Park, Cox Arboretum MetroPark, and Five Rivers MetroPark that promise to be an excellent location to watch the total eclipse from.

GETTING THERE

Dayton can be reached by commercial air travel. To reach it by car, drive north from Cincinnati for fifty-five miles on I-75.

TOTALITY DURATION

2 minutes 45 seconds

NOTES

The Dayton Convention and Visitors Bureau's website is an excellent place to start your total eclipse search at https://www.daytoncvb.com/.

Event	Time (EDT)	Altitude	Azimuth
Sunrise	7:09:00AM	0°	79°
Eclipse Start	1:53:25PM	57°	187°
Totality Start	3:09:21PM	51°	218°
Totality End	3:12:06PM	51°	219°
Eclipse End	4:25:29PM	40°	240°
Sunset	8:08:00PM	0°	280°

Findlay

Elevation: 778 feet
Population: 41,321
Main road/hwy: I-75/US 224

Overview

Findlay is the city that serves as the seat of Hancock County, and it is located forty miles south of Toledo. The official nickname of Findlay is "Flag City, USA." Findlay is actually home to a wide array of annual activities, including but not limited to Oktoberfest, the Springtime in Ohio Cat Show, the Boogie on Main Street, and the Flag City BalloonFest. Findlay is also home to the University of Findlay, which will have total eclipse education and events on its campus.

Getting There

Drive south from Toledo for forty-six miles on I-75 to reach Findlay.

Totality Duration

3 minutes 43 seconds

Notes

The Hancock Convention and Visitors Bureau website, https://visitfindlay.com/, is a good starting place to discover travel, hotel, and event information for the total eclipse.

Event	Time (EDT)	Altitude	Azimuth
Sunrise	7:05:00AM	0°	79°
Eclipse Start	1:55:50PM	56°	188°
Totality Start	3:10:39PM	50°	218°
Totality End	3:14:23PM	50°	219°
Eclipse End	4:26:34PM	39°	240°
Sunset	8:07:00PM	0°	280°

Fremont

Elevation: 627 feet
Population: 16,193
Main road/hwy: US 20

Overview

Fremont used to be called Lower Sandusky, and it is located along the west bank of the Sandusky River. It was later renamed to Fremont in 1849 as a means of honoring John C. Freemont, the American who worked to help acquire California by defeating Mexican forces in the Mexican-American War. The city was home to Rutherford Hayes, who served as America's President from 1877 to 1881. A couple of notable landmarks to visit in Fremont include the Rutherford B. Hayes Presidential Center, the Heinz Ketchup Factory, the Freemont Freeway, Spiegel Grove, and the Birchard Public Library.

Getting There

Drive south from Toledo on I-75, then merge onto I-90 and continue southeast. Exit onto OH 53 and continue south to reach Fremont.

Totality Duration

3 minutes 37 seconds

Notes

Visit Fremont's visitor website at https://www.fremontohio.org/visitors/ to find travel and tourism info for the total eclipse.

Event	Time (EDT)	Altitude	Azimuth
Sunrise	7:03:00AM	0°	79°
Eclipse Start	1:56:59PM	55°	190°
Totality Start	3:11:40PM	49°	219°
Totality End	3:15:17PM	49°	220°
Eclipse End	4:27:15PM	39°	241°
Sunset	8:05:00PM	0°	281°

Greenville

Elevation:	1,043 feet
Population:	12,771
Main road/hwy:	US 36/127

Overview

Greenville serves as Darke County's seat. The city was the location of Fort Greenville, which was built by the soldiers under General Anthony Wayne during the Northwest Indian War. Named for war hero Nathaniel Greene, its fencing covered fifty-five acres at the time and was the largest wooden fort in North America. Greenville is where the Great Drake County Fair takes place, and the fair runs for a total of nine days every August. The city also has the Garst Museum, which contains the most extensive collections of both Lowell Thomas and Annie Oakley, both of whom were born close to the city.

Getting There

Drive north from Cincinnati for eighty-five miles on US 127 to reach Greenville.

Totality Duration

3 minutes 56 seconds

Notes

The Darke County visitor website is the perfect place to start planning your visit at https://www.visitdarkecounty.org/.

Event	Time (EDT)	Altitude	Azimuth
Sunrise	7:10:00AM	0°	79°
Eclipse Start	1:53:11PM	57°	186°
Totality Start	3:08:24PM	52°	186°
Totality End	3:12:21PM	51°	218°
Eclipse End	4:25:06PM	41°	239°
Sunset	8:10:00PM	0°	280°

Hamilton

Elevation:	597 feet
Population:	62,092
Main road/hwy:	US 127

Overview

The seat of Butler County, Hamilton is located twenty miles north of Cincinnati. The city is a part of the Cincinnati Metropolitan Area, and it consists of three designated National Historic Districts: Rossville, Dayton Lane, and German Village. The city was declared to be the "City of Sculpture." The Pyramid Hill Sculpture Park may prove to be an interesting location to photograph the eclipse from. The meadow, forest, and garden sculpture environments will make for a unique Ohio total eclipse experience.

Getting There

Drive north from Cincinnati for twenty-three miles on US 127 to reach Hamilton.

Totality Duration

1 minute 46 seconds

Notes

Butler County's visitor website is the perfect starting point to explore total eclipse events and locations. Visit the website at https://www.gettothebc.com/explore/hamilton.

Event	Time (EDT)	Altitude	Azimuth
Sunrise	7:10:00AM	0°	79°
Eclipse Start	1:52:23PM	58°	185°
Totality Start	3:09:00PM	52°	218°
Totality End	3:10:47PM	52°	218°
Eclipse End	4:24:53PM	41°	240°
Sunset	8:09:00PM	0°	280°

Kenton

Elevation:	991 feet
Population:	8,135
Main road/hwy:	US 68

Overview

Kenton is located in the central part of Ohio. The city was named after Simon Kenton, a frontiersman of Ohio and Kentucky. Kenton is home to a wide array of social activities and side attractions that will definitely fill up the itinerary of an eclipse chaser. For instance, there is the Hardin County Courthouse, which serves as a centerpiece located in the heart of the public square. There is also a public library in Kenton, one of the Carnegie libraries in Ohio. The city possesses a museum worth visiting—the Hardin County Historical Museum, which is near the north side of the historic district. Other attractions include the Hi-Road Drive-in and the Kenton Theater.

Getting There

Drive south from Toledo on the I-75 and continue on the US 68 for seventy-one miles to reach Kenton.

Totality Duration

3 minutes 55 seconds

Notes

Visit Kenton's official website at http://www.kentoncity.com/ as a starting point for viewing the total eclipse.

Event	Time (EDT)	Altitude	Azimuth
Sunrise	7:05:00AM	0°	79°
Eclipse Start	1:55:24PM	56°	188°
Totality Start	3:10:19PM	50°	218°
Totality End	3:14:14PM	50°	220°
Eclipse End	4:26:29PM	39°	240°
Sunset	8:07:00PM	0°	280°

Lima

Elevation:	879 feet
Population:	37,149
Main road/hwy:	I-75

Overview

The municipality of Lima can be found in northwest Ohio. It is along Interstate 75, approximately seventy-two miles north of Dayton and seventy-seven miles south-southwest of Toledo. The county is where the Lima Army Tank Plant is located, and the plant till today remains the only producer of M1 Abrams. Lima was one of the original spots where oil was discovered in Ohio, and this discovery kicked off the "Oil Boom of Northwest Ohio." The William McKinley High School in Lima served as the set for the movie *Glee*, and the city was also the focus of the late 90s comedy *Lost in the Middle of America*.

Getting There

Drive south from Toledo on the I-75 for seventy-seven miles to reach Lima.

Totality Duration

3 minutes 50 seconds

Notes

The *Lima Ohio News* will have updates and information about the total eclipse. Visit their site at https://www.limaohio.com/.

Event	Time (EDT)	Altitude	Azimuth
Sunrise	7:05:00AM	0°	79°
Eclipse Start	1:54:47PM	56°	187°
Totality Start	3:09:43PM	51°	217°
Totality End	3:13:34PM	50°	219°
Eclipse End	4:25:56PM	40°	240°
Sunset	8:07:00PM	0°	280°

Lorain

Elevation:	610 feet
Population:	63,841
Main road/hwy:	OH 611

Overview

Lorain is the tenth largest city in Ohio by population and the third largest in greater Cleveland metro area. Lakeview Park was established as a means of providing more publicly accessible space on the city's waterfront, and it features a volleyball court, a beautiful open space, picnic shelters, lawn bowling, a historical rose garden, a playground on the beach, and an Easter egg basket. You also have the Lakeview Fountain, which has a multicolor display at night. The spray of the Lakeview Fountain is capable of going as high as thirty to fifty feet.

Getting There

Drive west from Cleveland on I-90 for twenty miles, then continue west on OH 611 to reach Lorain.

Totality Duration

3 minutes 52 seconds

Notes

The *Lorain Morning Journal* newspaper will have eclipse updates on their website at https://www.morningjournal.com/.

Event	Time (EDT)	Altitude	Azimuth
Sunrise	6:59:00AM	0°	79°
Eclipse Start	1:58:29PM	55°	192°
Totality Start	3:12:55PM	49°	221°
Totality End	3:16:47PM	48°	222°
Eclipse End	4:28:20PM	38°	242°
Sunset	8:02:00PM	0°	281°

Mansfield

Elevation:	1,240 feet
Population:	46,160
Main road/hwy:	US 30

Overview

Mansfield is located in the middle of Cleveland and Columbus via I-71. Downtown Mansfield is actually home to various art venues and side attractions. The downtown brickyard venue consists of various concert halls that draw crowds of over five thousand people. There is also a historic Renaissance Center that hosts and presents Broadway-style productions on an annual basis to more than fifty thousand people. These productions include comedy, classical music, lectures, concerts, and arts education programs. The Renaissance Performing Arts are also home to the Mansfield Symphony.

Getting There

Drive southwest from Cleveland on I-71 for seventy-two miles, then continue west on US 30 to reach Mansfield.

Totality Duration

3 minutes 17 seconds

Notes

Mansfield's https://www.destinationmansfield.com/ website will have updated information on total eclipse lodging and events.

Event	Time (EDT)	Altitude	Azimuth
Sunrise	7:01:00AM	0°	79°
Eclipse Start	1:57:11PM	56°	191°
Totality Start	3:12:15PM	50°	220°
Totality End	3:15:33PM	49°	222°
Eclipse End	4:27:47PM	38°	242°
Sunset	8:02:00PM	0°	280°

Marion

Elevation:	981 feet
Population:	35,997
Main road/hwy:	OH 4

Overview

Marion is located in—and also the seat of—Marion County. The city is situated in north-central Ohio, about fifty miles north of Columbus. The city features historic properties, with some of them being part of the National Register of Historic Places. The city of Marion is home to a wide array of museums, including the Heritage Hall & the Old Post Office, the Wyandot Popcorn Museum (which is touted as the only museum on the face of the Earth that is dedicated to chronicling popcorn and all its associated memorabilia), the Warren G. and Florence Kling Home (a Presidential site), and the Huber Machinery Museum.

Getting There

Drive from Columbus on OH 315 and US 23 for twenty-nine miles, then continue west on OH 309 to reach Marion.

Totality Duration

3 minutes 35 seconds

Notes

The Marion Visitors Bureau will have lodging and event information on their website at http://www.visitmarionohio.com/.

Event	Time (EDT)	Altitude	Azimuth
Sunrise	7:03:00AM	0°	79°
Eclipse Start	1:56:03PM	56°	189°
Totality Start	3:11:07PM	50°	219°
Totality End	3:14:42PM	50°	221°
Eclipse End	4:27:02PM	39°	241°
Sunset	8:05:00PM	0°	280°

Norwalk

Elevation:	719 feet
Population:	16,824
Main road/hwy:	US 20

Overview

Nicknamed the Maple City, Norwalk is located approximately ten miles south of Lake Erie and fifty-one miles west of Cleveland. Norwalk, Ohio, is home to the survivors of the Norwalk-Connecticut attack by the British in 1779. As a consequence, many of the oldest homes in the city feature a New England architecture and style. Some of these original houses can still be seen in the city. Just one of the various notable residents of Norwalk is Ronald Ray Hackenberger. He owns a collection of over seven hundred vehicles, most vintage and some highly valued.

Getting There

Drive south from Toledo on the I-280, then continue east on the I-90 for fifty-four miles, then continue south on the US 250 to reach Norwalk.

Totality Duration

3 minutes 54 seconds

Notes

Visit Norwalk's website at http://www.norwalkoh.com/ for more information.

Event	Time (EDT)	Altitude	Azimuth
Sunrise	7:01:00AM	0°	79°
Eclipse Start	1:57:36PM	55°	191°
Totality Start	3:12:09PM	49°	220°
Totality End	3:16:03PM	49°	221°
Eclipse End	4:27:48PM	38°	241°
Sunset	8:03:00PM	0°	280°

Sidney

Elevation:	951 feet
Population:	20,614
Main road/hwy:	I-70

Overview

The city of Sidney was named after the English poet Sir Philip Sidney. Many of the elementary schools were also named after popular English writers, and the city was the recipient of the All-America City Award in 1964. Sidney has a drive-in movie theater, the Auto-Vue. It opens during the summer. There is also a Farmers' Market around the court square during the growing season. The Farmers' Market puts on annual events, including Kids Around the Square, an Easter Egg Hunt, and a Chocolate Walk. You can also check out the Shelby County Historical Society. Artifacts belonging to Shelby and Sidney are available for viewing from Monday through Saturday.

Getting There

Drive north from Cincinnati for ninety-two miles on the I-275 and I-75 to reach Sidney.

Totality Duration

3 minutes 52 seconds

Notes

Visit Sidney's official website at http://www.sidneyoh.com/ for updated eclipse event links.

Event	Time (EDT)	Altitude	Azimuth
Sunrise	7:08:00AM	0°	79°
Eclipse Start	1:54:08PM	57°	187°
Totality Start	3:09:16PM	51°	218°
Totality End	3:13:09PM	51°	219°
Eclipse End	4:25:44PM	40°	240°
Sunset	8:08:00PM	0°	280°

TOLEDO

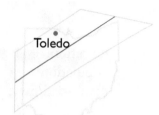

Elevation: 614 feet
Population: 276,491
Main road/hwy: I-90/I-75

OVERVIEW

Although originally founded in 1833, it was re-founded in 1837 and incorporated into Ohio after the Toledo War drew to a close. The Toledo Zoo can be found here, and it is the first zoo to feature a hippo aquarium exhibit. There is also the National Museum of Great Lakes and the Toledo Metroparks system, which includes well over 10,000 acres of space and consists of the Toledo Botanical Garden and the University/Parks Bicycle Fair. Toledo also has the University Bike and Walking Trail.

GETTING THERE

It is possible to fly directly into Toledo on commercial airlines. Otherwise, drive west on I-90 from Cleveland for one hundred fourteen miles to reach Toledo.

TOTALITY DURATION

1 minute 46 seconds

NOTES

Be aware that the northern suburbs of Toledo will not see the totality. Locations farther south will enjoy a longer total eclipse.

Event	Time (EDT)	Altitude	Azimuth
Sunrise	7:04:00AM	0°	79°
Eclipse Start	1:56:45PM	55°	189°
Totality Start	3:12:13PM	49°	218°
Totality End	3:14:00PM	49°	219°
Eclipse End	4:26:51PM	39°	240°
Sunset	8:07:00PM	0°	280°

Upper Sandusky

Elevation:	846 feet
Population:	5,509
Main road/hwy:	US 30

Overview

Upper Sandusky is situated right along the upper Sandusky River (where its name is derived from), a river that flows north to Sandusky Bay. The city is famous for being the place astronaut Neil Armstrong spent much of his childhood. The history of Upper Sandusky is quite rich. It originates as a European-American settlement, and it dates all the way back to the end of the American Revolutionary War. The city was a reserve for Native Americans. Many indigenous Wyandot maintained their residences there until 1842 when they were forced out.

Getting There

Drive south from Cleveland on the I-71, then continue on US 30 to reach Upper Sandusky.

Totality Duration

3 minutes 54 seconds

Notes

Upper Sandusky's city website at https://uppersanduskyoh.com/ is an excellent starting place to find information about the total eclipse. The city is nearly on the centerline, making it a prime viewing location.

Event	Time (EDT)	Altitude	Azimuth
Sunrise	7:04:00AM	0°	79°
Eclipse Start	1:56:07PM	56°	189°
Totality Start	3:10:55PM	50°	219°
Totality End	3:14:50PM	50°	220°
Eclipse End	4:26:55PM	39°	241°
Sunset	8:05:00PM	0°	280°

Van Wert

Elevation:	778 feet
Population:	10,654
Main road/hwy:	US 30 / US 127

Overview

Van Wert is Van Wert County's municipal seat. The city was named after Isaac Van Wart, who helped capture Major John Andre in the Revolutionary War. Van Wert is notable for being a center for peony cultivation, and the city has continued to host—although on an "on and off" basis—the Van Wert Peony Festival ever since 1902. The city plays home to the Brumback Library, which is America's first county library. There is also a lively community art center, the Wassenberg Art Center, in the city, as well as Van Wert Civic Theatre.

Getting There

Drive north on US 127 from Cincinnati for one hundred forty miles to reach Van Wert.

Totality Duration

3 minutes 8 seconds

Notes

The Van Wert Convention and Visitors Bureau website will have updated total eclipse information on their website at http://visitvanwert.org/.

Event	Time (EDT)	Altitude	Azimuth
Sunrise	7:09:00AM	0°	79°
Eclipse Start	1:54:14PM	56°	186°
Totality Start	3:09:29PM	51°	217°
Totality End	3:12:38PM	51°	218°
Eclipse End	4:25:25PM	40°	239°
Sunset	8:11:00PM	0°	280°

Cuyahoga Valley National Park

Elevation: 889 feet
Main road/hwy: I-271

Overview

The Cuyahoga Valley National Park is situated along the Cuyahoga River between Akron and Cleveland. The Cuyahoga Valley Scenic Railroad also runs through the park, and you can also find the Canal Exploration Center in the park's northern reaches. This center provides an account of the history of the nineteenth-century waterway. The Towpath Trail follows the historic route of the Ohio and Erie Canal. Brandywine Falls is a major visitor attraction in the park. Note that the park service warns that the rocks and fences can be slippery, and multiple accidents have occurred over the years.

Getting There

Drive south from Cleveland on I-77 for fifteen miles, then continue east on Snowville Road to reach the park's visitor center.

Totality Duration

3 minutes 27 seconds

Notes

Cuyahoga's website will have official eclipse and access updates at https://www.nps.gov/cuva/index.htm.

Event	Time (EDT)	Altitude	Azimuth
Sunrise	6:57:00AM	0°	79°
Eclipse Start	1:59:12PM	55°	193°
Totality Start	3:13:51PM	48°	222°
Totality End	3:17:19PM	48°	223°
Eclipse End	4:28:58PM	37°	242°
Sunset	7:59:00PM	0°	280°

Indian Lake State Park

Elevation: 1,013 feet
Main road/hwy: US 33

Indian Lake State Park

Overview

Indian Lake is the centerpiece of the state park. At nearly six thousand acres, the man-made lake offers a multitude of recreational activities before and after the total eclipse. Water skiing, boating, camping, and fishing are all popular with the locals. The park is pet friendly. Make sure to maintain control of your animal, as there may be a large crowd and the excitement may scare some pets. Note that many parks fill up well in advance of a total eclipse, so do not delay in making reservations. Bring warm clothes, as April can still be chilly in Ohio.

Getting There

Drive north from Dayton on the I-70/75 for fifty-six miles, then continue east on US 33 for seventeen miles to reach the park and lake.

Totality Duration

3 minutes 55 seconds

Notes

Ohio's state park website dedicated to Indian Lake is http://parks.ohiodnr.gov/indianlake. This website will have camping and event updates prior to the total eclipse.

Event	Time (EDT)	Altitude	Azimuth
Sunrise	7:07:00AM	0°	79°
Eclipse Start	1:54:48PM	56°	188°
Totality Start	3:09:48PM	51°	218°
Totality End	3:13:44PM	50°	219°
Eclipse End	4:26:07PM	40°	240°
Sunset	8:08:00PM	0°	280°

Kelleys Island State Park

Elevation: 590 feet
Main road/hwy: Ferry Access

Overview

Kelleys Island functions as a village in Erie County. It is one of the few Ohio locations to view the total eclipse over Lake Erie. It was originally called Sandusky Island by the British, but it was eventually renamed by Datus and Irad Kelley in 1840, as the brothers almost bought the whole island. Known as Lake Erie's Emerald Isle, there are many areas to enjoy boating, fishing, and other water sports. Be aware that weather in early April can be chilly on Lake Erie.

Getting There

Take the private ferry from Marblehead, Sandusky, or use your own boat to access Kelleys Island State Park.

Totality Duration

3 minutes 29 seconds

Notes

The park's website, http://parks.ohiodnr.gov/kelleysisland/, will have updated total eclipse information for camping and events. Plan well in advance if you want to be on the island for the total eclipse.

Event	Time (EDT)	Altitude	Azimuth
Sunrise	7:01:00AM	0°	79°
Eclipse Start	1:57:53PM	55°	191°
Totality Start	3:12:28PM	49°	220°
Totality End	3:15:58PM	49°	221°
Eclipse End	4:27:46PM	38°	241°
Sunset	8:04:00PM	0°	281°

Lake Erie

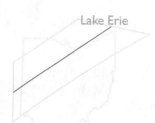

Elevation:	569 feet
Main road/hwy:	Multiple

Overview

Lake Erie is the fourth largest of North America's five Great Lakes. Also, of all the Great Lakes, it is the smallest by volume, shallowest, and southernmost. It is situated on the border between Canada and the United States, and the surface area of the river is divided into water boundaries by different county, state, federal, and national jurisdictions. The lake will be a busy place to view the total eclipse from. Except for a few locations, your back will be to the lake while viewing the event. To see the eclipse over water, you will need a watercraft to take the shot from or be at a few select locations.

Getting There

The lakeshore borders much of northern Ohio, including the cities of Toledo, Sandusky, Cleveland, and Conneaut.

Totality Duration

Varies depending on location.

Notes

Historically, the air temperature is in the forties and fifties along Ohio's Lake Erie shoreline in April. Be prepared for variable weather.

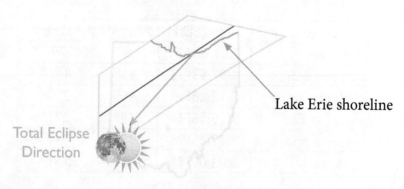

REMEMBER THE OHIO TOTAL ECLIPSE
April 8, 2024

Who was I with? _____

What did I see? _____

What did I feel? _____

What did the people with me think? _____

Where did I stay?_____

Enjoy other Sastrugi Press titles

2024 Total Eclipse State Series by Aaron Linsdau
Sastrugi Press has published state-specific guides for the 2024 total eclipse crossing over the United States. Check the Sastrugi Press website for the available state eclipse books: www.sastrugipress.com/eclipse

50 Wildlife Hotspots by Moose Henderson
Find out where to find animals and photograph them in Grand Teton National Park from a professional wildlife photographer. This unique guide shares the secret locations with the best chance at spotting wildlife.

A Small Pile of Feathers by Gerry Spence
Gerry Spence reveals his spiritual, loving, and sometimes humorous sides, depicted in his devotion to family and preserving the wild places he writes of as though they were inscribed on his own bones and in his own blood.

Antarctic Tears by Aaron Linsdau
What would make someone give up a high-paying career to ski alone across Antarctica to the South Pole? This inspirational true story will make readers both cheer and cry. Fighting skin-freezing temperatures, infections, and emotional breakdown, Jackson Hole native Aaron Linsdau exposes the harsh realities of being on an expedition.

Cache Creek by Susan Marsh
Five minutes from the hubbub of Jackson's town square, Cache Creek offers the chance for hikers to immerse themselves in wild nature. It is a popular hiking, biking, and cross-country ski area on the outskirts of Jackson, Wyoming.

Cloudshade by Lori Howe, Ph.D.
The poems of *Cloudshade* breathe with the vivid, fragrant essence of life in every season on America's high plains. Extraordinarily relatable, the poems of *Cloudshade* swing wide a door to life in the West, both for lovers of poetry and for those who don't normally read poems.

Journeys to the Edge by Randall Peeters, Ph.D.
What is it like to climb Mount Everest? It requires dreaming big and creating a personal vision to climb the mountains in your life. Randall Peeters shares his successes and failures and provides the reader with some directly applicable guidelines on how to create a life vision.

Lost at Windy Corner by Aaron Linsdau

Windy Corner on Denali has claimed lives, fingers, and toes. What would make someone brave lethal weather, crevasses, and slick ice to attempt to summit North America's highest mountain? The author shares the lessons Denali teaches on managing goals and risks. Apply the message to build resilience and overcome adversity.

Prevailing Westerlies by Ed Lavino

With clarity and intensity, Lavino's photographs express a longing for the natural world and hope for its future. An intimacy with the Rocky Mountain West born of long familiarity and close observation is evident. These beautiful black and white images are timeless, yet decidedly modern.

Roaming the Wild by Grover Ratliff

Experience the landscape and wildlife photography of Grover Ratliff in this unique volume. Jackson Hole is home to some of the most iconic landscapes in North America. In this land of harsh winters and short summers, wildlife survives and thrives. People from all around the world travel here to savor the rare vistas.

Sleeping Dogs Don't Lie by Michael McCoy

A young Native American boy is taken from his home after tragedy strikes, grows up in middle America, and through his first real adult summer searches for Wyoming artifacts, falls in with the subversive Dog Soldiers Resurrected, and attempts single-handedly to solve the murder of his treasured coworker.

So I Said by Gerry Spence

The collected sayings of Gerry Spence provokes readers into thinking about their own vision of the world. As a lawyer with decades of experience in defending the defenseless, he's fought against giants. His insights provide a grander vision of how the nearly invisible world of the justice system in *So I Said*.

Voices at Twilight by Lori Howe, Ph.D.

Voices at Twilight is a guide takes readers on a visual tour of twelve past and present Wyoming ghost towns. Contained within are travel directions, GPS coordinates, and tips for intrepid readers.

Visit Sastrugi Press on the web at www.sastrugipress.com to purchase the above titles in bulk. They are also available from your local bookstore or online retailers in print, e-book, or audiobook form.

Thank you for choosing Sastrugi Press.
www.sastrugipress.com
"Turn the Page Loose"

About Aaron Linsdau, Polar Explorer & Motivational Speaker

Aaron Linsdau is a polar explorer and motivational speaker. He energizes audiences with life and business lessons that stick. He is an expert at building resilience to overcome adversity by maintaining a positive attitude. Aaron teaches audiences how to eat two sticks of butter a day to achieve their goal. He shares how to deal with constant pressure, burnout, and adrenaline overload.

He holds the world record for the longest expedition in days from Hercules Inlet to the South Pole. Aaron is the second only American to complete the trip alone, eating seventy pounds of butter on the expedition.

This solo expedition is more difficult than climbing Mount Everest with a team. Being alone dramatically increases the challenge. Aaron uses emotionally stirring stories to show how to overcome adversity, manage risk and safety, and survive unimaginable conditions. He relates these stories to business challenges and shows how the common person can achieve uncommon results.

Aaron collaborates with organizations to deliver the right message for the audience. He connects his stories to business realities. Aaron loves inspiring audiences. Book Aaron for your next event today.

"Never Give Up"
Adversity • Attitude • Resilience • Risk • Safety

Read reviews, be inspired, and learn more about Aaron Linsdau at:
www.ncexped.com
www.aaronlinsdau.com

Smartphone link

Aaron at the South Pole after 82 days alone in Antarctica.

Printed in the USA
CPSIA information can be obtained
at www.ICGtesting.com
LVHW021348280124
769813LV00057B/1413